It may seem strange, but once he had passed his Baccalaureate his father made no objection to his following in the footsteps of his two brothers, and going to Paris to study art. It is true that Duchamp displayed remarkable gifts which the "Amis des Arts de Rouen" had recently recognised by awarding him the medal for outstanding achievement they gave to encourage young talent.

Jacques Villon acted as his guide through the dives at the foot of Montmartre where chansonniers mingled with painters and cancan dancers. In this lively atmosphere he rapidly recovered from failing the exam for the Ecole des Beaux Arts and enrolled at the Académie Julian where he learned the tricks of the trade and the do's and don'ts of the studio.

He was fascinated by humourists, and adored their inimitable word games, or cartoons that included ridiculing the world's most famous smile by giving her a moustache. He rapidly adopted their smiling but savage approach to life, and when their first salon opened at the Palais de Glace in 1907, he was among the exhibitors.

*Marcel Duchamp as an unknown youngster with well-known figures such as Adolphe Willette, Jacques Villon, Charles Léandre, and Abel Faivre, at the private view for the first Salon des Artistes humoristes.*

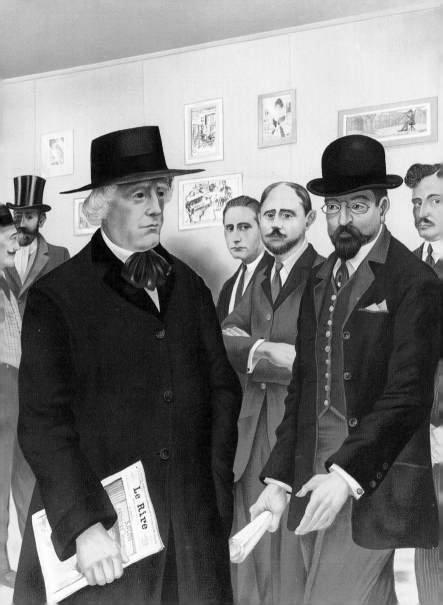

Up to 1911 Duchamp's career followed a routine pattern, with exhibitions in Spring at the Independents, and in October at the Salon d'Automne. He progressed from Impressionism to Fauvism, then did a spell under the influence of Cézanne, whose work had already led Picasso and Braque to reduce everything to cubes.

Via the work of their disciples, Cubism was revealed to the general public that year. There would be no more of the quiet, peaceful family Sundays in Puteaux where the three brothers brought together initiates in the new movement, when they would intersperse serious art discussions with outdoor games; one of the best of these involved throwing dice to run miniature horse-races with interesting bets.

Duchamp, who was riveted by the scandal surrounding the cubist painters, pinned his hopes on a painting intended for the 1912 Indépendants, which looked like a large time-lapse photograph in colour.

The Salon committee rejected it.

He was mortified to find himself having to call and remove his *Nude Descending a Staircase*, just as the private view was about to open.

*Marcel Duchamp removing his* Nude Descending a Staircase *from the Salon des Indépendants, at the Cubists' request.*

8

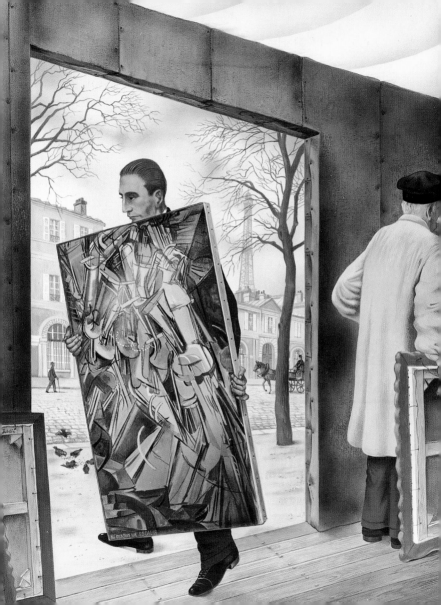

Duchamp took the rebuff very badly, and decided to desert the cubist coterie, by going abroad to get a fresh perspective.

A few days before he was due to leave, he was taken by the poet Guillaume Apollinaire and the exuberant painter Francis Picabia to an unforgettable evening at the Théâtre Antoine where they saw *Impressions d'Afrique*, Raymond Roussel's stage adaptation of his book of the same title.

While most of the audience whistled and booed, Duchamp was transfixed by the turns shown on stage: an earthworm playing a zither, the wind-powered clock from the land of Cockayne, the statue made of corset-stays pulled along on rails made of calf's lights... the evening opened a window for him onto something truly new, a spiritual influence which could take the place of the formal influences which had touched him hitherto.

He took the train to Munich in mid-June, and from the moment he arrived turned his hotel room into a studio. And he set to work on a project he had been mulling over for years: to paint a picture which would no longer be an interpretation of reality, but pure creation. So he juxtaposed mechanical elements and visceral forms, and conceived *The Bride*.

*Marcel Duchamp, Gabrielle and Francis Picabia, and Guillaume Apollinaire at a performance of* Impressions d'Afrique *by Raymond Roussel at the Théâtre Antoine.*

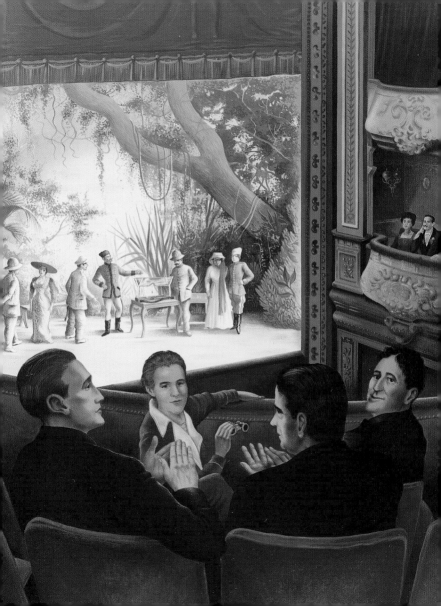

On New Year's Day 1913 Duchamp was, as usual, visiting his parents, who had moved to Rouen after his father retired. Wandering through the town's narrow streets, he came across the Gamelin chocolate shop which he had not seen for several years. The rhythmic beat of the steam engine with its balance wheel was still driving the chocolate grinder in the window as it had since the middle of the previous century. He looked at the mixer with its heavy granite wheels, and realised that this mechanism was indispensable to bachelors who are well known to grind their own chocolate. He was in no doubt that here was one of the elements of The Bachelor Machine with which he wanted to confront The Bride he had made in Munich.

On February 17th that year, America discovered modern Art at the Armory Show. Duchamp with his *Nude Descending a Staircase* became overnight as famous on the other side of the Atlantic as the most illustrious old master. News of his success reached him in Paris but he remained unmoved.

Like Leonardo da Vinci, he had become a sort of engineer working in secret on the elaborate preparatory drawings for the Large Glass. Only reading his copious notes about it would make them intelligible.

*Marcel Duchamp at the window of the Gamelin chocolate shop whose grinder inspired one of the elements of the Large Glass.*

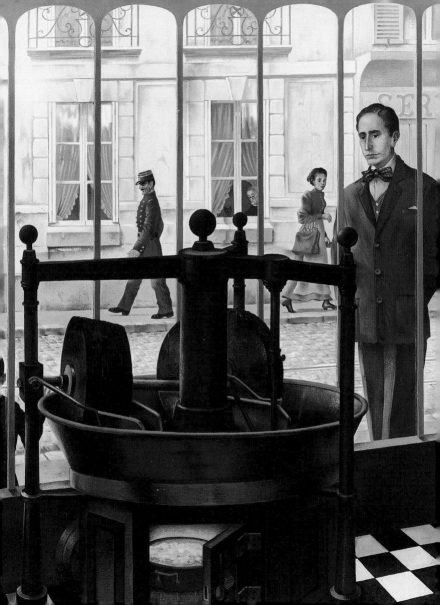

Henceforth nothing, in his eyes, could rival the beauty of the objects dispensed by the industrial era; he even saw some of them as the perfect materialisation of his concepts. The time had come to act: he bought a bottle rack, which the manufacturer called a "hedgehog" because of its shape, and he signed it. Thus was born the first work of art labelled "toute faite".

In August 1914 war broke out. Duchamp was passed unfit, so escaped mobilisation, and took the advice of the American painter Walter Pach to set off for New York.

When he arrived in the New World he was received like a film star. His first impressions of the skyscraper city were published in the papers, he was idolised in the salons, lionised by the ladies, so he left his French provincial reserve in the cloakroom and indulged his new-found freedom.

The fame he had won two years before was still intact, and America was waiting for him to shock her. He was happy to oblige. He adopted the English expression "ready made" as he thought it sounded better than the French "toute faite", and made works of art out of a snow-shovel, a coat stand, a typewriter cover, and a urinal which he dubbed "Fountain" and signed with the pseudonym R. Mutt.

*Marcel Duchamp in the Bazar de l'Hotel de Ville, buying one of the objects for which he would coin the term* Ready Made *in New York in 1915.*

14

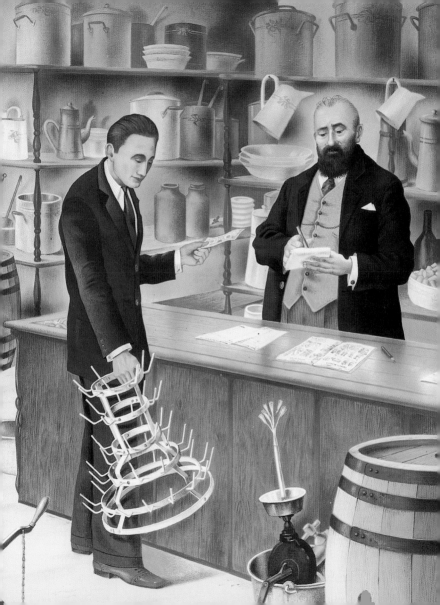

When the United States in turn declared war, Duchamp took refuge in South America. With the return of peace in 1919 he briefly returned to France to see his family. He found Paris about to be swamped by a wave of Dadaism, joined the movement for just long enough to add a moustache and beard to a reproduction of the Mona Lisa, and write at the bottom of the picture the five letters L.H.O.O.Q. (which reads *"elle a chaud au cul"*, in English "she has a hot ass"), then left again for New York.

Not long after his return to New York he contrived to split his personality, and gave birth to an alter ego, the enigmatic Rrose Sélavy, immortalised in a photograph by Man Ray. Rrose Sélavy acquired rapid fame by handing down tricksy apophthegms in the style of the Pythia speaking to the priests at Delphi:

*Du dos de la cuillère au cul de la douairière.* [From the glass of a watch to a dowager's crotch.]

*Un mot de Reine; des maux de reins.* [A queen's refrain; kidney pain.]

*Sa robe est noire, dit Sarah Bernhardt.* [The sari's smart, Sarah Bernhardt.]

Her "learned lady" act seduced the Surrealists who had taken the place in Paris of the rapidly fading Dadaists. If we are to believe André Breton, Rrose Sélavy even dictated, from across the Atlantic, some of his famous conundra to the poet and medium Robert Desnos.

*André Breton cross-examining Robert Desnos during a transatlantic telepathy session with Rrose Sélavy, alias Marcel Duchamp.*

16

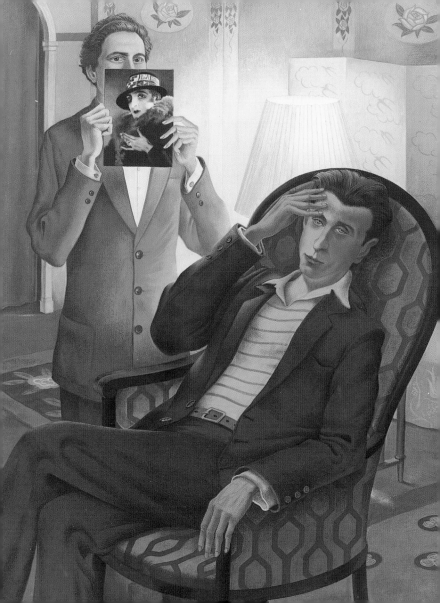

While Rrose Sélavy was indulging in the art of word play, Duchamp was struggling to complete the Large Glass, to the point where at the beginning of 1923 he took the decision to leave it finally unfinished. He revoked the lease on his Broadway studio, and embarked on the next steamer leaving for the Old World of Europe, where he had decided that he would devote himself to his favourite hobby, chess.

In the next few months he launched his career with two remarkable conquests. He won the title of champion of Upper Normandy, and then, by being hosed down as he was playing chess, won over the audience of the film *Entr'acte* (shown, of course, in the interval of the ballet *Relâche* [= no performance] put on by the Ballets Suédois at the Théâtre des Champs Elysées).

He moved into Montparnasse, and before long the gossip in the artists' cafés was that he had given up art. And that was in fact what he did for close on ten years, while he took part almost every year in the French chess championship, and was a member of the national team in tournaments at the Hague, Hamburg, Prague, and Folkestone.

*Marcel Duchamp the chess player, standing in as an actor in the film* Entr'acte, *directed by René Clair and Francis Picabia, while Erik Satie looks on in amusement.*

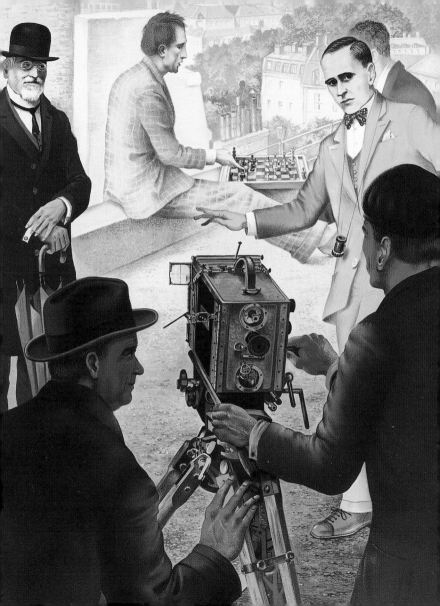

In 1935 he gave up competing and returned to his first love in life. For his come-back, he wanted to have direct contact with the public, so he booked a stand at the 33rd Concours Lépine new products fair, at which he exhibited a multiple-copy art-work at a price everyone could afford. His invention — optical disks which he called *Rotoreliefs* — was supposed to give an impression of depth when spun on the turntable of a gramophone.

Duchamp awaited his customers behind his counter, surrounded by a *Japanese Fish* which swam endlessly round and round, a *Hot Air Balloon* trapped in the movement of a permanently rising draught, and a *Bohemian Glass* which made you dizzy without having drunk its contents.

This was not the first time Duchamp had taken an interest in optical illusions. In the twenties he had already been excited by the phenomenon of retinal persistence and stroboscopes.

The jury of the Salon des Inventions gave him an honourable mention, but the hoped-for popular success failed to materialise, and he was left to pack up his unsold goods at the end of the show.

*Marcel Duchamp, presenting his* Rotoreliefs *on his stand at the Concours Lépine, gets a visit from Henri Pierre Roché.*

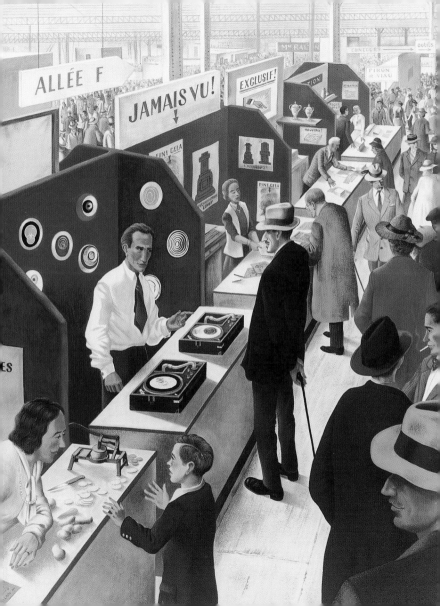

In 1936 Duchamp was forced to travel to the United States where a dreadful tragedy had occurred on a road in Connecticut. While being transported *The Large Glass* had shattered into thousands of pieces with the lorry's vibrations.

Duchamp saw that the damage was not irreparable and resolved to rebuild it; both to protect and to stabilise it, he decided to sandwich it between two thick sheets of glass.

Far from being oppressed by the event he found that fate had arranged things quite well, and the symmetry of the cracks looked rather intentional; instead of being disfigured the work was actually embellished.

In the top half, issuing from *The Milky Way*, pierced by the *Three Draft Pistons*, a stream of cracks crossed *The Bride*. The lower half was cracked into a web of lines which rose in the *Nine Malic Moulds* and fanned out towards *The Water Mill*, *The Sieves*, and *The Chocolate Grinder*, so that only the *Oculist Witnesses* had come through the accident more or less unscathed.

Once restored, *The Bride Stripped Bare by her Bachelors, Even* recovered all its mysterious allure and will continue, like the Egyptian sphinx, to defy every kind of exegesis.

*Marcel Duchamp repairing his large glass* The Bride Stripped Bare by her Bachelors, Even, *after it was broken while being transported.*

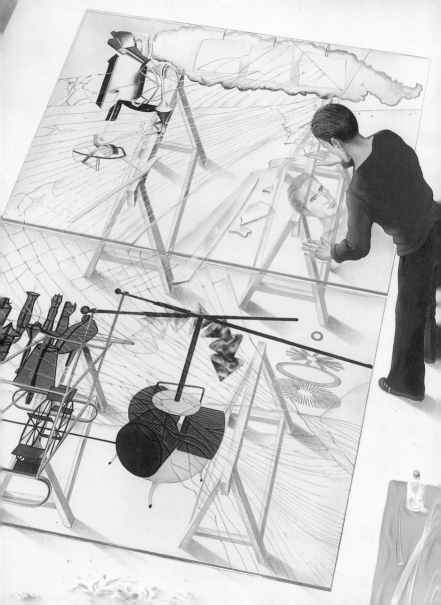

Two years later André Breton and Paul Eluard organised an International Exhibition of Surrealism in Paris and asked Duchamp to be its "referee/generator". He transformed a gallery for the occasion into an unusual grotto, by hanging 1200 coal sacks from the ceiling, carpeting the floor with thousands of dead leaves, and heating this frigid atmosphere with a glowing brazier. The private view was set for the evening of January 17th, but a few hours before the opening Duchamp had flown the coop and taken a boat to England.

Fleeing from the German invasion in 1940 Duchamp reached Arcachon — shortly before the Germans did. After a long delay he succeeded, in 1942, in crossing into the Free Zone with an "ausweis" as a cheese salesman, and from there to Morocco whence he sailed for America.

In New York he found many artists who, like him, had escaped from Nazi repression — in particular André Breton, with whom he organised another surrealist exhibition as a benefit for French children and prisoners. Duchamp took several hundred metres of string and wove endless cobwebs, which got in the way of people's view of the pictures and gave them the feeling they were in a room that had been abandoned for decades.

*Marcel Duchamp as referee/generator, installing the International Exhibition of Surrealism with Max Ernst, Salvador Dali, and Man Ray.*

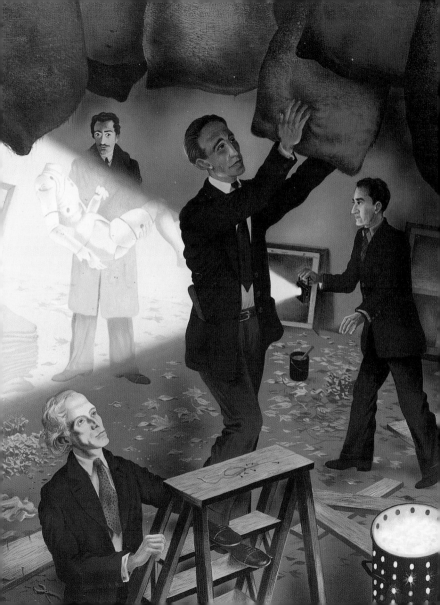

After the war was over Duchamp decided to stay in the United States, and took American citizenship.

When New York celebrated the fiftieth anniversary of the Armory Show, his *Nude Descending a Staircase* was an object of veneration and Duchamp's genius was finally recognised after all those years of being eclipsed by the glare of Picasso's glory. All over the world he began to receive the honour he deserved. Alas within five years he died, during a visit to France, at Neuilly on 2nd October 1968. He was 81.

But Duchamp had decided he would not go down in history as an old rebel who had repented. He was, after all, the son of a notary, and he was to bequeath to the world a posthumous work. It caused a sensation; no one had guessed that he had been working in total secrecy for the past twenty years on what was to be his masterpiece: *Given: 1. The Waterfall, and 2. The Illuminating Gas.* Two small round holes cut into a double door are the only means offered for the visitor to "know" at last... And there a woman lies immodestly spread on a bush, lulled by the constant movement of a distant waterfall, offering up her nakedness, for all eternity, to every passing voyeur.

This is the rendezvous Duchamp prepared for pilgrims to Philadelphia.

*Marcel Duchamp contemplating in the secrecy of his studio his last work* Given:, *which would only be revealed after his death.*

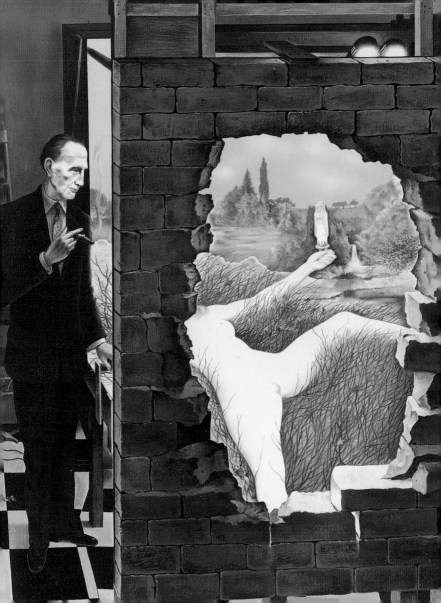